art-to-go

A Traveler's
Guide to
Painting in
Watercolors

First published in the United States of America by:
Quarry Books, an imprint of Rockport Publishers, Inc.
146 Granite Street
Rockport, Massachusetts 01966-1299
Telephone: (508) 546-9590
Fax: (508) 546-7141

Distributed to the book trade and art trade in the United States by:
North Light, an imprint of
F & W Publications
1507 Dana Avenue
Cincinnati, Ohio 45207
Telephone: (800) 289-0963

Other Distribution by:
Rockport Publishers
Rockport, Massachusetts 01966-1299

ISBN 1-56496-248-2

10 9 8 7 6 5 4 3 2 1

Art Director: Lynne Havighurst
Designer: Diane Sawyer
Editor: Shawna Mullen

Nice Flower Market, page 27, from the collection of Loraine and Richard Bunker.

Cover Postcard Images: Pages 24, 36, and 27

Printed in Hong Kong by Excel Printing Company

A TRAVELER'S GUIDE TO

Painting in Watercolors

LYNN LEON LOSCUTOFF

QUARRY BOOKS,
ROCKPORT, MASSACHUSETTS

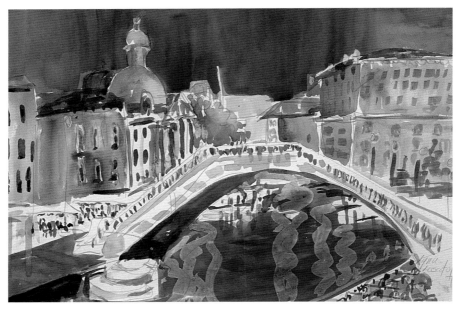

Venice, *Lynn Leon Loscutoff*

ACKNOWLEDGMENTS

I would like to thank my husband, Jim, for giving me wall space, quiet space, and for being so supportive, helpful, and...for making longer stops on driving trips.

I gratefully thank the contributing artists who have generously shared their combined experience of more than two centuries of painting and traveling. Space does not permit all of the vast material they have provided to be included in this book; however, be assured that the contributing artists have been more than eager to get you securely launched on an endless journey of pleasure and satisfaction. How can you explain a lifetime of knowledge and painting adventures? My peers and I have logged a million miles. I have been enriched and humbled by their giving response. I thank them profusely, and we all wish you "Happy Traveling."

Special thanks to my mentors, who helped me draw out my creative self; Betty Lou Schlemm, Zygmund Jankowski, Marty Holmes, Bob Rogers, Shawna Mullen—my editor and Isabelle's mom; and to Ann Longman, Carolyn Hoffstetter (for sending me materials); Helen Rubenstein and Ann Lange (for being great travel companions); Phillis Poor (for her friendship and for being the "Bath" connection); Sarah and Allie Loscutoff; and to James, Rachael, and Jessica Randall, for being joyful and full of love.

—*Lynn Leon Loscutoff*

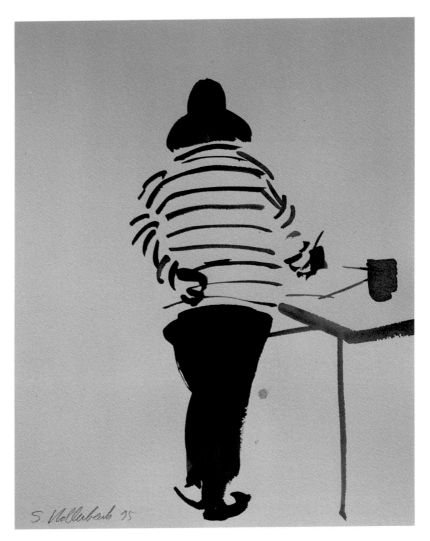

Serge Hollerbach

CONTENTS

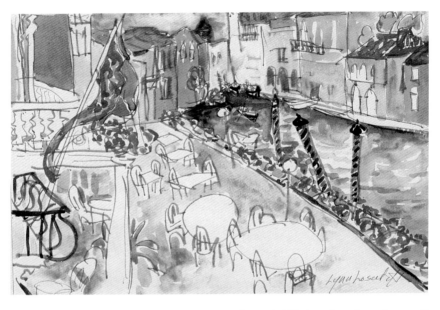

Venice from My Window, *Lynn Leon Loscutoff*

INTRODUCTION

*Y*ou can be an artist in motion wherever you go. Is traveling and painting like going to meet a new lover? It certainly carries its own special excitement. Landscapes, people, patterns, light, shadows, and objects can all belong to you.

Travel gives birth to discovery. But why not simply travel and then bring your experiences home to paint? Painting on the move stimulates improvisation. Awareness is sharpened. One learns to manipulate objects, reorganize relationships, and design as you go.

Whether you sketch for immediate reference, stored impressions, or later work, material becomes truer and more valuable when it has been recorded on site. Sketching helps to make decisions about placement, values, shapes, color, and texture. Many of the important elements for finished pieces can be worked out through the artist's shorthand—sketching. Direct painting while traveling is an even more valuable form of shorthand, and often the only means of quickly capturing the essence of a subject.

In the pages that follow, you'll find instruction, anecdotes, hints, and tricks of the trade for painting outside the studio. The seven featured artists share a wealth of information, and their own personal style of capturing a subject. And traveling doesn't have to involve plane tickets; it can be local. Whether looking from the window at home, starting out for a day's hike, or planning an extended trip, be prepared for inspiration.

PACKING YOUR BAGS

The smallest kit, the artist's travel companion (bag #1), can go anywhere. Carry it in your pocket, purse, or in a "fanny pack" around your waist.

Most people think painting in watercolor requires a special room. However, if you paint and travel, the world can be your studio. All you really need to prepare yourself for a lifetime of painting and traveling can fit in your pocket or in a small backpack. Before you can paint on the go, you'll want to collect some materials that can easily be kept close at hand. A photographer's vest, available through photography or sporting goods stores, can be a real asset on foot or in a vehicle. It has 18 pockets to hold painting equipment, photography equipment, and your passport and wallet.

Depending on the type of trip, I travel with any-where from one to three "art bags." Each is designed for portability, and each nests comfortably inside the next larger size. The artist's travel companion—bag #1—can be any small zippered bag (4" × 6"/10 cm × 15 cm-size works well) filled with a sketchbook, eraser, pen and ink, pencils, watercolor crayons, marking pens, a tiny water-color set and a collapsible brush. Carry water in an empty film container. It is also good to include a camera—either a Polaroid, or a small Canon-type with automatic everything.

I often add bag #1 to a larger canvas or nylon bag, which I call art à la carte—bag #2. This bag should have handles and a shoulder strap to carry additional sup-plies—especially blocks of paper. I use 10" × 14" (26 cm × 36 cm) Arches watercolor blocks in both hot and cold press papers. All of these blocks have their own backing, which acts as a portable easel.

This larger bag, art à la carte (bag #2), carries bag #1 and more supplies, but is still small enough to fit into a briefcase or back-pack.

My favorite bag for traveling very long distances is the road trip bag—bag #3—which combines the equipment carried in bag #1 and bag #2 and then some. No matter where you are traveling, do not check your art sup-ply bags when you board the plane. Carry them with you. You can always replace lost luggage containing under-wear, but you may never find Naples yellow in Russia.

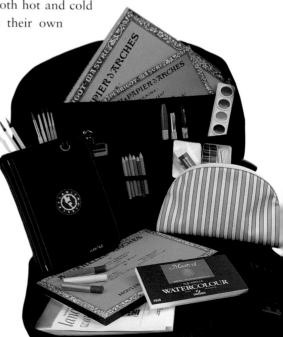

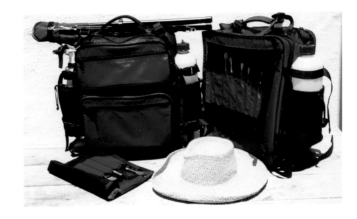

The Art Pack, designed by traveling artist Jan Hurd, is a backpack with a brush holder, water bottle, space for a folding chair, and room enough for a palette and a 12" × 16" (30 cm × 41 cm) watercolor block.

Pack at least some of your clothes in hard, water-proof luggage. These bags are heavier than the soft-sided variety, but will serve you well for transporting finished art work. Take along a mailing tube with rolled full sheets of 22" × 30" (56 cm × 76 cm) watercolor paper: completed paintings can be mailed home or repacked in this tube, and it protects the paper's corners and edges. Put extra luggage name tags in your suitcases, so that if any tags are accidentally torn off, you will have replacements.

Stow blocks of watercolor paper in plastic bags under your clothing. (I once watched from the plane as a suitcase containing twenty-four completed watercolor paintings was dropped in a puddle.) Take a luggage cart, and bring extra bungee cords. These come in handy as you walk through a countryside with your painting materials.

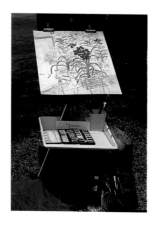

It is always a good idea to have a flashlight when traveling, painter or not. A visor light, a bicycle light on a headband, or a two-direction Double Header light—that illuminates in front and below—can give you light for night painting. Bug repellent (Chase Away is a good one) now comes in a wrist band that will fit in all three art bags: Nothing to leak, wear it or pin it to your easel. A folding umbrella with a clip to attach to your chair or easel can provide you with protection from the sun or rain. Another handy item is a lightweight folding stool (the Artist's Seat Bag) that can hold your art supplies.

Being creative can involve more than painting: a plastic raincoat tucked into bag #3 could cover a painting or you in case of a sudden shower. A Velcro™ strap that attaches to a board can make a portable flat surface for sketching while walking or watching an activity. Brush holders made from eyeglass cases can be clipped to your pocket or attached with Velcro™ to your easel. A plastic jar can hold your tube paints. A container with a strap can hang your water and brushes over your shoulder if you are standing, or hang on the seat in front of you when you are on the move.

Contents of the road trip bag (bag #3) set up and ready for action. This bag can include:

An easel (with collapsible tripod and paint tray)

Tissue or paper towels

Removable shoulder strap

22" x 30" (56 cm x 76 cm) watercolor paper or large blocks of watercolor paper

24-color watercolor palette (John Pike and Pelikan make good palettes)

Six art clips and a roll of masking tape

Folding hat

Plastic bottle of water

Container to hold your water (Collapsible containers are available from camping equipment stores. A cut-off plastic soda bottle or a plastic ziplock bag are other good, cheap solutions.)

Swiss Army knife

Natural sponge

First aid supplies

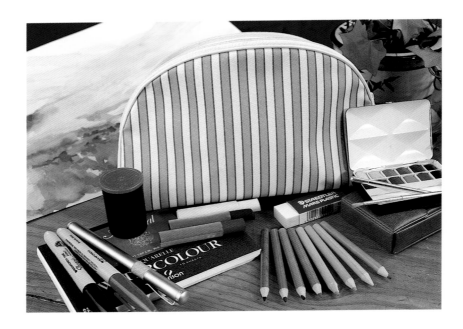

*B*rushes, paints, paper, easels—the types and styles of these tools and supplies can be overwhelming. Here are some suggestions for what to take along. Brushes are an extension of your hand; your magic wand. The lower the number printed on the brush, the finer the mark it will make.

Consider packing folding brushes in bag #1 and a two-sided brush (Aquarelle makes a great one)—one flat side and one round side—in bag #2. In bag #3, I also add these brushes: a one-inch, synthetic flat, a Number Two red sable, a Number Ten round, a two-inch flat, a Number

Six rigger, and a Number Three rigger for line work and calligraphy. A wraparound, folding brush case—Winsor & Newton make a good one—is a secure way to store and transport brushes. Look for cases that have twenty or more slots. Give careful thought to where you are going as you pack your paints. Take brighter colors to hot-weather climates. Always take at least one "warm" and one "cool" version of all the complementary colors. Small watercolor traveling kits come with pan or dried paint, which is less likely to run in hot weather. Some pocket-size watercolor kits come with tubes, which I prefer for long trips. I put them in a strong ziplock bag or plastic jar, since squashed tubes can leak. Disposable palettes are available; the John Pike plastic palette with a cover is a favorite of mine.

Robert Wade's Flying Tip:

When flying, mark a personal symbol (a clearly visible splash of paint or bumper sticker will do nicely) on all your luggage. It makes bags much easier to identify quickly at airports. I pack my favorite Moroccan paint bag, then I tuck it into a duffel bag with my socks and underwear to add protection. Of course all of my painting gear travels with me as carry-on luggage.

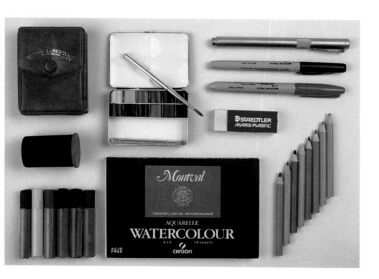

Paper comes in many types and sizes. Hot press is smooth, so paint dries quickly. Cold press is rougher and works well with many washes. Weight indicates the paper's roughness and thickness: 90 lb. is usually sketchbook weight; 140 lb. Arches cold press is the most commonly used watercolor paper; 300 lb. is good for making large, full-sheet paintings, and is tough enough to withstand wiping out or making changes. I like to travel with watercolor blocks. Many other artists prefer taping sheets of paper to plastic, a thin sheet of aluminum, or even foam core, which is lightweight and easy to carry.

Hot vs. Cold

I prefer hot press watercolor paper for fast work because it is smooth and the paint color stays on the surface. It is also less absorbent. Cold press paper comes in various weights; the heavier the weight, the rougher the surface. Experiment to find the weight and size that best suits your style. Most suppliers will send samples upon request.

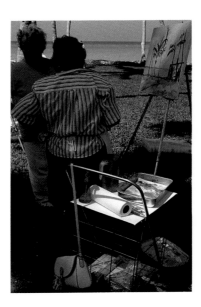

A fellow painter in Florida uses her shopping cart to carry paints and to act as an easel.

You won't always need an easel, but when you do, the Field Artist Company has designed a folding easel that comes with its own nylon carrying case and weighs only six pounds. The French easel is made of wood and folds for use standing or sitting, but it is heavy. Some artists use TV trays or folding chairs turned upside down; others work on the ground, sitting on small, folding camp stools. A homemade easel of cardboard or foam core can be improvised on arrival and then thrown away before the trip home.

Whatever supplies you choose, remember that you will have to tote them, so aim for versatility, and pare down as much as possible.

Luggage-cart bungee cords are now made with little handles. Empty eyeglass cases make handy brush holders.

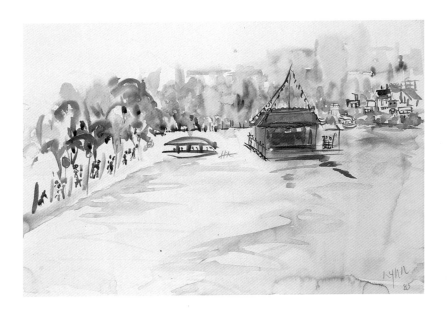

Hong Kong
Lynn Leon Loscutoff

*I*t has been said that when shoppers arrive in Hong Kong by plane, they hit the ground running, with charge cards in hand. When you have traveled any distance to paint, there is the same sense of urgency to capture everything in sight. Often, the difficult chore is eliminating visual stimuli and focusing. Some painters look for a ready-made composition. Others combine elements. Some artists take a great amount of time "reading" the subject. What excites you? Important factors are fleeting light, changing shadows, and your schedule. Let your senses feel the area. Usually, it's instinctive; you'll know your spot. History tells us that John Singer Sargent walked straight ahead, not looking to either side, stopped, put down his equipment, and started painting.

When choosing a spot, think about whether you are a public or private person. If you think walking a dog is a good way to meet people, wait until you try painting on a busy street. If you want to chat and be noticed, just pick your spot. Some artists paint on location and sell their work. Painting and selling can buy more paints for painting and selling. As for me, I hope that no one will talk to me and break my stream of consciousness. I often wear earphones attached to a tape recorder. Sometimes, I pretend not to speak the language. Sometimes, I really don't. I have had wonderful experiences in many countries. People usually admire and respect what you are doing, especially if they live in the area where you are painting. The fact that you enjoy the site enough to paint it is a shared appreciation.

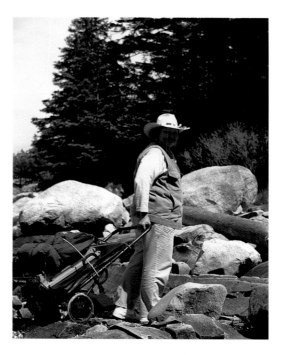

Phillis Bezanson ventures into remote, nearly inaccessible spots to paint the rocky shores of Maine. Her art buggy was made by her father, George Krishfield, from found objects and an old baby carriage. With large wheels for maneuvering over uneven terrain, it carries an easel and art supplies.

*T*hese snapshots were taken from the bus to help refresh my memory of details in the landscape later on. Painting from moving vehicles can be tricky, but the effort is worthwhile because the results are often amazing. "Alla prima" is the term used for painting directly, in any medium, without sketching. Direct painting can serve as the same type of gestural, spontaneous response as sketching. When you are on the road, this type of "seat of the pants" travel painting takes alla prima one step further; it could almost be called à la carte.

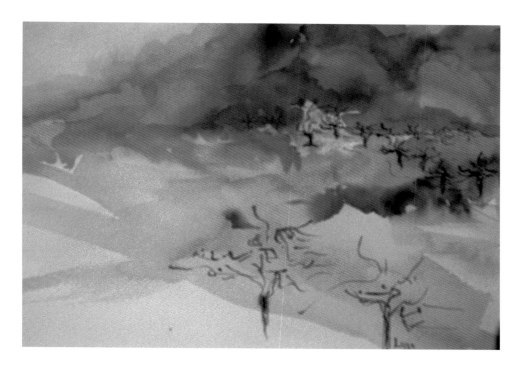

When capturing a landscape from a moving vehicle (from a bus with the painting that follows), start by brushing in the large shapes first. Don't wait for anything to dry. The landscape will be racing by, and you'll probably have no idea how much time you'll have to pull together the pieces, so use the first sweep of color to concentrate on shapes.

With the second sweep, add more definition to the shapes of hills and trees that you have painted. If there is time to add detail, put some in. If the landscape is passing by too rapidly, you can add suggestions of remembered shapes later, if they are needed in the composition.

While painting the cherry trees, the temptation to use a "calligraphy" stroke was overwhelming. But in these situations, there's no time to get picky and overwork one area of your painting. With a Number 3 rigger brush I captured the dancing movement of the cherry trees.

Painting by Bus

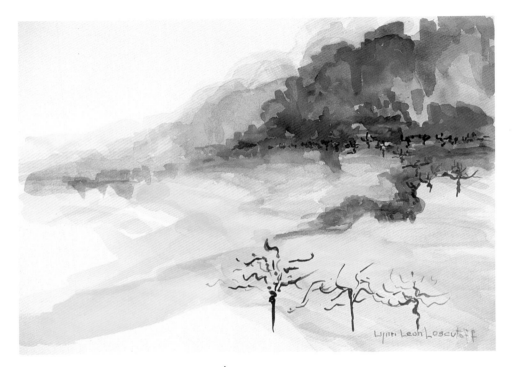

Lynn Leon Loscutoff

*T*his painting, done from a bus chugging along to the Great Wall of China, combines the elements of the landscape. The new sights were mesmerizing as we drove through the landscape—peaks and valleys, blossoming cherry trees, and the overwhelming vastness of the countryside. I felt connected to the soft colors and simple brush strokes of Oriental-style painting.

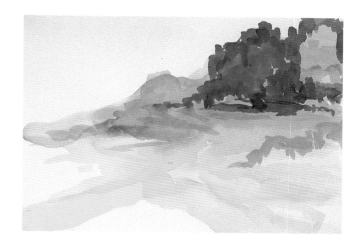

First, paint a quick wash of watercolor on the paper in the general shape of the passing landscape.

When you travel with a group of non-artists, as I did in China, you have to become a little antisocial if you want to concentrate and paint. I try to sit on the last seat of the bus, so that I have privacy and do not disturb others. I hang my water container—in this case a small plastic thermos with a strap—from the seat in front and put my palette on a piece of plastic beside me. Here, I used a 10" × 14" (26 cm × 36 cm) watercolor block of cold press paper, and worked directly with a one-inch flat brush and a Number Three rigger for fine lines. I did no preliminary sketching with pencil or ink. On buses, or when painting in any moving vehicle, adding detail needs to be done quickly, since the scene you are observing is soon out of sight.

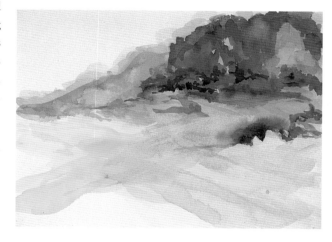

As the scenery streams past, continue to layer on color, adding definition with each stroke.

Painting by Car

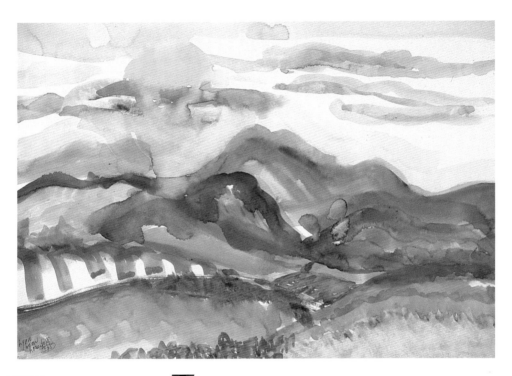

During this trip, a desert sunrise splashed across my paper. Later in the trip, I had forty-five minutes at the Grand Canyon. What a choice I had to make! I could either use the facilities, or paint—such is the "traveling with husband" dilemma.

I paint wherever I go, and if I happen to be traveling by car instead of by bus—I paint in the car. For years, my job was to drive Route 66. My husband had been drafted by the Boston Celtics professional basketball team and I drove from San Francisco to Boston and back— spring and fall.

On this sojourn, we made a brief stop at Niagara Falls. I sketched on site and quickly painted while the image was fresh in my mind. I folded out the paper to make two surfaces, then almost flung the paint to imitate the spray of foam and water I had seen.

Desperate as I was to paint, my art interest had to take a back seat. Sunrise on the desert; cactuses blooming; wildflowers massed against a mountain range; all flashed past my window. Too much for an artist to bear. When, finally, my husband drove, I became a "quickdraw artist."

During cross-country trips, I balance an Arches hot press block on my lap. My favorite water container for traveling in the car is a dog's water dish (made by Dr.'s Foster & Smith, Inc.), since it can be hooked onto the arm rest or the open glove compartment door without spilling. I prefer a John Pike palette for painting in vehicles: it offers more mixing surface in the cramped space of the car.

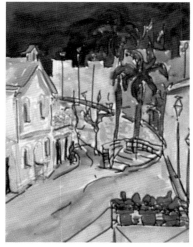

A tropical street scene, captured during a break from riding.

Ville Franche-sur-Mer, *Lynn Leon Loscutoff*

Painting by Taxi

*T*he passenger seat of a car may offer a clear view out the windshield, but, it can't compare to the roomy back seat of a British taxi. On this trip, I was able to convince the driver to stop long enough in front of a charming garden for me to grab a sketch. Gardens in every country have their own special flavor, and the gardens in Bath are as lovely as any I've seen. I love painting gardens and I have traveled to many locations to paint them.

Photographs taken from the back seat of a British taxi, and added to the sketchbook for future reference.

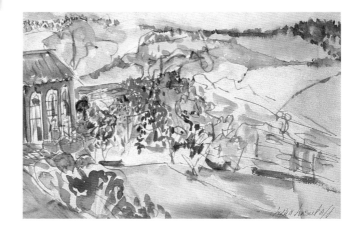

One of a series of garden sketches painted from the back seat of a British taxi.

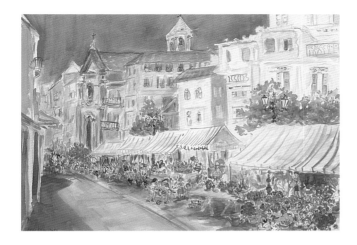

A flower market in Nice, painted using an empty orange crate as an easel.

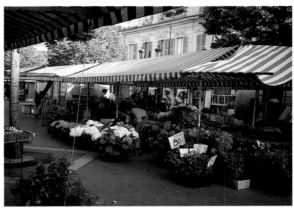

For quick takes of whatever type of landscape you travel through, try filling a sketchbook of "on the run," "instead of lunch," and "everywhere on the move" sketches and paintings. Focus on the fast line and color rendering, and leave the details for later. You will be surprised at how capturing scenery quickly becomes easier with practice.

Try to paint every chance you get—propping your watercolor block on any convenient surface: an orange crate, a balcony railing, even the edge of a window box will do in a pinch. Whenever your vehicle stops (whether for a nightcap or for the night)—grab your sketchbook and trusty bag #2 and, before heading indoors, capture the scene on the street in front of you. That is exactly what I did to paint this scene along the French Riviera.

Getting the Picture

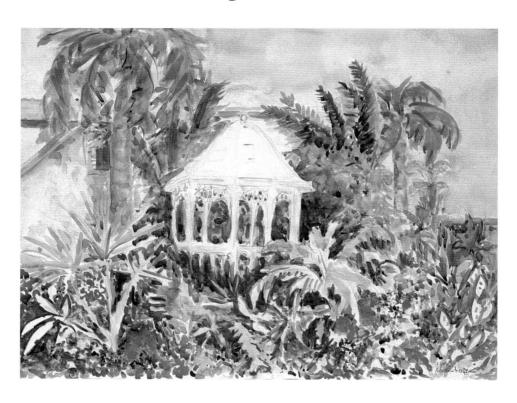

To make some space between the house and the tree, and from the tree to the gazebo, I added shadows. Here and there, I added some even darker darks and touched some aureolin yellow sunlight on the sides and tops of the plants.

Whether you are on the road in a car, bus, or taxi, there are times when you have to stop to get the big picture. A sunlit day in Florida prompted me to take such a painting pause. I stopped, took a picture, and set up bag #3 and my Field Artist easel. I loved the way the palm trees broke up this scene in strategic spots. I painted them to make an implied circle around the gazebo, then created a square and broke its center with the gazebo.

As I painted, the sun grew hotter and it was getting to be noon. Noon is not a good time to paint; the light is overhead and the shadows have changed. I usually try to finish work right on the spot: If you return to a painting, you are never in the same frame of mind as you were when you began—and it shows. This day, however, I decided to finish indoors. Outside I was working with my board very upright. When I put the paper down on a table, I saw that I'd goofed. I had closed in the space. Consulting a Polaroid photo, I checked the dark areas, fixed space and proportion problems, then added some shadows to the left side of the building. I also tried to stop fixing things before I went too far—one of the most difficult tasks with a painting. And it doesn't just happen to you and me—there was a very famous artist who was caught sneaking around a museum making a correction on his painting.

A preliminary sketch for placement, this is not meant to be a value sketch—strictly an outline. If you do choose to make a value sketch, remember that values create contrast and should never be equal in proportion.

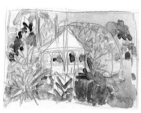

I drew the whole scene very quickly, on a full sheet of 22" × 30" (56 cm × 76 cm), Lanaquarelle paper.

The darkest dark in this painting is next to the lightest light at the right of the gazebo. I left a quiet space on the other side. The pink house makes a great warm background.

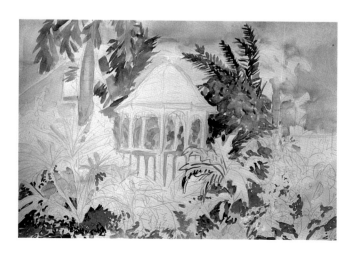

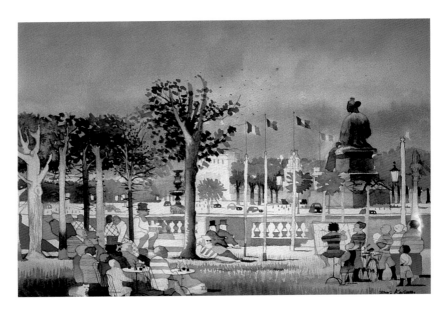

Paris A.M.
Dong Kingman
From the collection of
Dong Kingman, Jr.

Capturing the spirit of a city in paint can be as exciting as traveling in a busy metropolis for the first time. Everywhere you look, the fervor of activity, the drama of moving people, traffic, joggers, bicyclists, and skaters all weave together to form intriguing patterns. How to capture this spirit is something artist and traveler Dong Kingman knows well. Kingman lives in one of the world's most exciting cities—New York. And though he has spent sixty years traveling and painting, his simple approach to equipment remains unchanged: He still carries only a tiny stool to sit on, and places his work on the ground in front of him.

Perched on his stool, Kingman attaches paper to a piece of cardboard and tilts this makeshift easel by placing a rock or a book underneath. He often does a preliminary sketch to work out the dark and light patterns in a picture, thinking of them as yin and yang. He then balances the abstract shapes to work out overall composition and structure. Sturdy, 300 lb. Arches paper in full sheets, 22"× 30" (56 cm × 76 cm), is about the largest he ever paints— partly because his studio is on the 11th floor and the elevator is small. Half-sheet, 140 lb. watercolor paper will also work, and is a handy size for painting on the move, but Kingman prefers 300 lb. because it has more body for painting, correcting, and making changes.

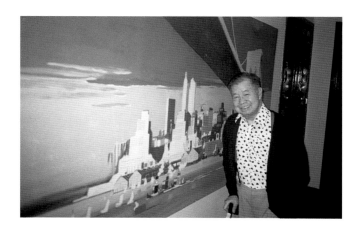

Dong Kingman (and one of his large paintings) outside of his studio. If you look carefully at the figures in his paintings, you will notice that they are all looking in the same direction or doing the same thing.

Painting Light and Dark Patterns

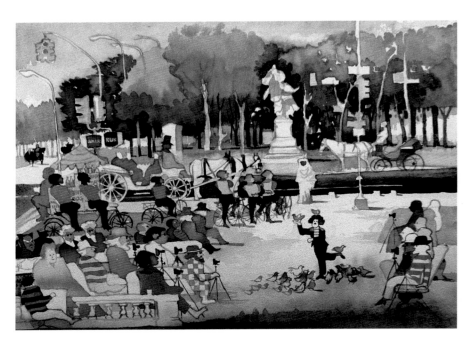

The Plaza in Central Park, New York
Dong Kingman.
From the collection of Rocky Aoki. Kingman adds realistic details with a small brush—cameras, glasses, and whiskers.

When painting a city scene, Dong Kingman considers himself a portrait painter of the contour and spirit of the cityscape. He freely moves the buildings and other elements to suit the design he has in mind. I had the pleasure of visiting him in New York, where one only has to step outside the door to experience the activity that continues to fuel his artistic inspiration. In an effort to capture a mood and project it on paper, Kingman advises letting your imagination play with all the elements on the streets around you. Let colors

reveal themselves as you portray the rhythms of the characters you see. Kingman says that is what an artist does—he sees the difference.

Kingman works out the base colors and color patterns of the painting with a preliminary sketch. Using a wet-on-wet technique, Kingman begins by painting the sky. Next, he lays in washes for the trees in the upper part of the picture. Using a medium brush, he mixes a little sepia with the greens and blues behind the statue. He continues to paint from left to right, leaving small spots for things he may add later (including imaginary characters.) When the first washes are dry, he paints in a lighter green over them. Kingman approaches color in terms of Chinese painting, using a limited palette with subtle gradations.

Back in the studio, Kingman adds vivid colors and people to liven his overall composition. He plays with color relationships, adjusts color balance, and carries the bright red of the cyclists' jerseys into the figures. Unity of color helps evolve the abstract, basic composition where this imaginary stage show is played out. Finishing in the studio gives him the opportunity to continue to weave the figures together with all of the shapes.

Kingman carefully layers washes to build the intensity of the colors.

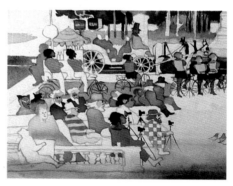

When finishing the painting in his studio, Kingman used a small brush to draw the group of figures and to give them color.

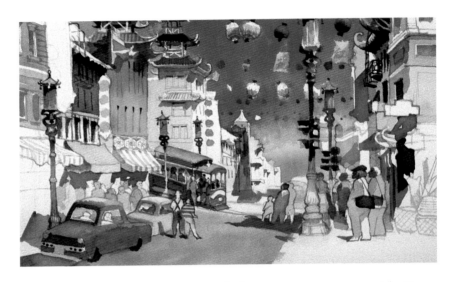

Chinatown, San Francisco
Dong Kingman
From the collection of
Rocky Aoki. Kingman,
adding details to finish
the buildings and the
floating paper lanterns,
used a natural gray wash
over the street, which he
finds especially important
for the foreground.

As we travel from coast to coast with Dong Kingman, he says that it takes many drawings and paintings to do a portrait of a city, especially one as complicated as San Francisco.

To paint San Francisco's Chinatown, Kingman first worked out key points in a black-and-white preliminary drawing. He considers the buildings, parks, and street lights to be the major subjects, punctuated by the colorful, whimsical passersby. Using three gradations of values, he uses a medium brush to apply delicate washes of blue-gray, green, and a neutral mix of green and burnt sienna. Then, with a larger brush, he applies lay-in washes to the shadowed side of the buildings.

You must plan carefully if you adopt Kingman's hard-and soft-edge technique. Wet the paper first and carefully stroke on the color, allowing it to bleed softly. Next, concentrate on the subject matter. Here, Kingman uses a medium brush to make the pagoda deep green, and a fine brush to add details to the cable cars. Once the overall pattern of a composition is in place, Kingman examines it carefully for balance, and to see if the rhythm moves him happily through the painting. When balance is achieved, he continues to add detail and color.

Kingman's painting of Chinatown begins with soft washes of color. The gentle yellow contrast on the walls (see below) also adds a sunny spot.

Details such as the awnings, baskets, and the colorful shapes of riders on the streetcar are added with a fine brush on top of the first wash of paint.

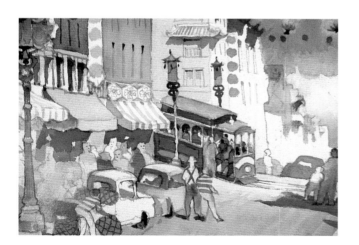

 # ON FOOT

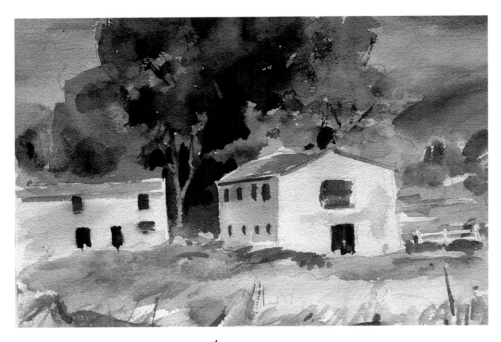

Road to Pisa
James Wisnowski

There are times when the only way to get the picture you want is to venture out on foot. When I travel on foot I like to paint right in my sketchbook, just in case I have to leave in a hurry.

Painting in watercolor on the move is not as set as you might think: There is plenty of freedom to make changes. This is especially true when you are walking and the landscape is not moving quickly past. The newness of a subject and the relative speed at which you must work may invite mistakes, but corrections can be made. Some artists sketch first, and spend a long time on placement,

details, shapes, and interlocking areas. When I paint, I often change things as I go. A drawing may be the basis for a good painting, but, when I get caught up in the excitement of working with color, I tend to ignore my drawing.

In this section, artists Robert Wade, Nancy Sargent Howell, and James Wisnowski share their paths with us as they trek on foot to sketch and paint. Wade pockets a tiny sketch pad so that he can sneak paintings of people working in markets. Howell climbs through medieval ruins, well-equipped with a backpack full of paints and supplies. Wisnowski leads biannual trips to teach students how to capture the patterns and shapes of the landscape while traveling. Each artist demonstrates his own unique style of capturing life's moving tableau.

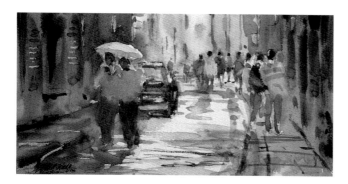

On morning walks, Robert Wade paints on foot. This quick water-color sketch was done in Brussels.

Choosing a Spot

◆ Weather is important. Stay out of the wind. Direct sunlight on your paper will reflect in your eyes and your colors won't be true. You will also tire faster.

◆ Be aware of private lands and hidden dangers. Indian reservations in the United States require permission. While painting outdoors in New Zealand, a friend of mine had a passing driver stop to tell her that she was in a poisonous snake area. Red ants are no fun either.

◆ Get comfortable. A folding stool and an umbrella may mean more to carry, but if you fall in love with a spot in the desert you might be thrilled to have them.

Artist Robert Wade adds:

◆ If you intend to paint away from the beaten track, always leave explicit information and directions with someone.

◆ Leave the place the way you found it; clean up your mess.

◆ Before leaving a property, remember to thank the owner.

Fast Vignettes

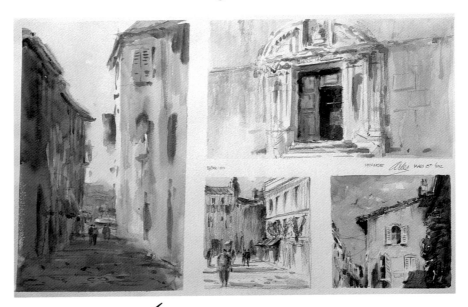

Artist Robert Wade uses a divided-sheet method to multiply his subject options—a great way to sort out the surroundings. Here, he captures scenes of Arles, France.

Robert A. Wade, often called the Australian Ambassador of Watercolor, has traveled to nearly every corner of the world during his 50-year painting career. Although his archive of slides and reference photographs numbers more than 10,000, Wade loves to get out of the studio to paint on location. He has perfected the art of choosing a spot and quickly capturing the sights in a series of vignettes—painted simply by turning in one direction, then another. Before you set out in the morning, advises Wade, make a simple grid with four or more strips of tape on watercolor paper. The different-size boxes that result will keep you moving and thinking about the landscape as you paint, and will set a rhythm going.

No matter what your location, Wade recommends a folding tripod easel (he favors the aluminum Stanrite 300 for its light weight and sturdy construction). Rest a clipboard on the brace between the easel's tripod legs to make a neat shelf for palette, water containers, and brushes. Besides keeping everything within reach, the shelf will also help anchor the easel to the ground.

When he teaches on location, Wade positions his paper straight up so that the group can see his work. On foot, he usually paints in spiral-bound sketchbooks: a pocket-size (6" × 4" /15 cm × 10 cm) Pentalic for quick sketches, and a larger version (14" × 11"/ 36 cm × 28 cm) for more sustained works.

Robert Wade, demonstrating painting techniques in Boccadasse, Italy. His easel doubles as a handy shelf, while his trusty Moroccan painting bag sits on the ground beside him.

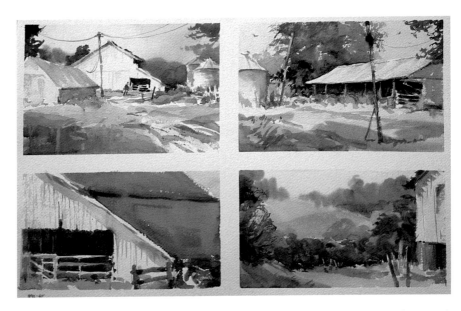

Landscape paintings of Illinois, U.S.A. Wade suggests using wide tape to quickly divide a sheet into different-size painting areas. Then, he says, find subjects to fit the formats you have given yourself.

For Wade, a good drawing is the basis of a good painting: Size is secondary. His chosen subject dictates which sketchbook he will use. Small books allow him to work in secrecy, capturing people at their work, in the local markets, or in any other environment where it helps to be relatively anonymous. Aside from their convenience, the palm-size books are good camouflage for an artist—making it appear that Wade is writing a diary.

Larger sketchbooks are best for situations when there is more time to turn out a detailed drawing—planes, trains, or any other place that offers a chance to draw while traveling.

When traveling and painting, Wade suggests giving your work a title before you begin. Even if you are an

accomplished artist, all the visual stimuli of travel can be distracting. Giving the work a title will help you focus. Paint the center of interest first; watch light and shadow, and straight and broken edges; mix colors right on the paper; and keep an eye on values—these are five more of Wade's rules to paint (and travel) by.

Finally, Wade advocates picturing something of personal significance taking place on the site that you are painting. Doing so will bring more emotion to the finished work. "Involve yourself in the painting," says Wade, "if the viewer responds, you have succeeded."

There is no preliminary drawing or pencil underworking in this nylon pen sketch.

Another example of quick, on-site sketching.

Intuitive Landscapes

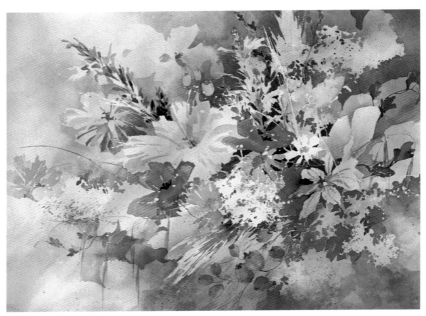

Howell uses a Number Ten round brush for details, and a Number Two rigger brush for small lines. Although her painting style is loose, she intuitively calculates design elements and checks positive and negative edges. When she finishes, she glazes the painting and checks its strong, dark pattern.

Nancy Sargent Howell returns each year to a favorite spot in the Tuscan village of Castelli, southeast of Rome. She and her students climb through the medieval ruins and walk the lovely valleys and vineyards. A genetic pull may be additional motivation for returning to Tuscany each year, since Howell is related to master painter John Singer Sargent, who painted near here also. In the impromptu work above, Howell captured lush, wild cyclamens—flowers that grow ankle-deep in Tuscany. "Flowers, grapes, and buildings reflecting the afternoon sun—all of these thoughts were in my mind as I

let the paper take the direction of my paint," says Howell.

Travel has taught Howell to paint in an "intuitive style"; she lets the painting develop from the surroundings—whether she is painting a landscape, seascape, or an abstract. Positive and negative shapes evolve as she works her wet-on-wet paintings. Her backpack has lightened considerably since she discovered that a limited palette of a warm and a cool of each primary color, and a combination of transparent, semi-opaque, staining, and non-staining paints could do everything she needed. Howell now works with six basic colors, developing her painting palette from new gamboge yellow, raw sienna, Antwerp blue, French ultramarine blue, permanent rose and cadmium red. She mixes neutral colors from those in her basic palette, and uses a technique that moves color over every area of the painting.

Wild flowers placed against the backdrop of a building in the distance create a spur-of-the-moment arrangement for an outdoor painting. To begin, Howell paints lines of masking fluid on the paper to keep some white for the grass. She then drops watercolor directly onto the wet paper and lets it move.

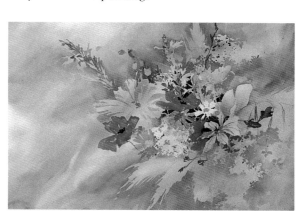

The placement of a slender stalk of lavender works to throw the focus of the painting off-center. Howell does most of her painting with a one-inch flat brush, which she holds at the very end so that it moves freely.

Classical Compositions

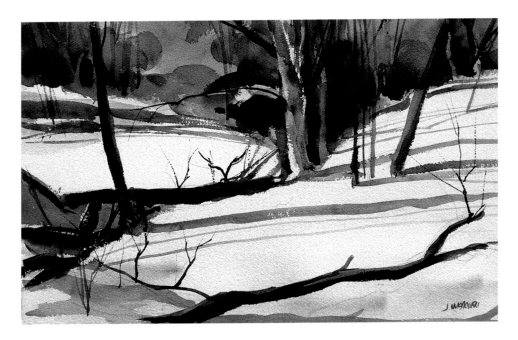

A finished S pattern painting which shows shadowing and a developed center of interest with contrasting values, colors, and detail.

Artist James Wisnowski leads two painting trips each year: one traveling on a barge through the Loire Valley, and the other walking the cities where Michelangelo worked and pausing to paint in Florence along the Ponte Vecchio. While in the northern United States, he also walks to paint snow scenes such as this one.

Even when on the move, Wisnowski is concerned with realism and, in particular, with composition. Classical ideas of composition suit him best. He plans balanced arrangements of masses and draws shapes accurately. He teaches his students to plan patterns before letting the brush touch the page: "Pattern is developed through the use of connecting shapes of the same value," says Wisnowski, "letting the eye travel through the painting. Patterns are balanced much like a seesaw."

A total of nine "patterns" are recognized standards in the design of paintings: *L* pattern, *O* pattern, *S* pattern, *stripes* pattern, *triangle* pattern, *light over dark base* pattern, *dark over light base* pattern, *light with balanced darks* pattern, and *dark with balanced lights* pattern.

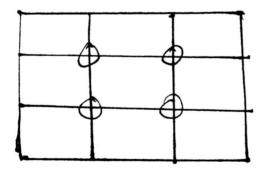

Even when traveling, James Wisnowski takes the time to compose his work. Here, his diagram of the Rule of Thirds divides paper to form a structure for the composition. Place the center of interest in one of the eyes of the rectangle; select one of the remaining three eyes for the secondary center; create balance by placing large, heavy masses close to the middle, lighter masses at the edges.

Step 1: Create an initial pencil line drawing to show the largest shapes. (Note the underlying S pattern.)

In this demonstration, Wisnowski illustrates the *S* pattern. The four-step process begins with a line drawing. Color is added in layers. Although disciplined, this style of painting offers good results for even the most footloose artist.

Step 2: Wet the background with clear water. While the paper is still wet, combine the main colors (here, cobalt blue and burnt sienna) and begin by painting the sky. Wisnowski's style is bold and direct. For the tree line in the background, he mixes burnt sienna, burnt umber, cobalt blue and alizarin crimson.

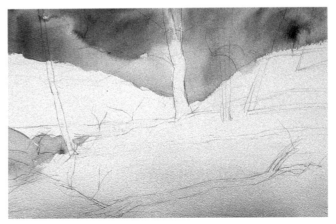

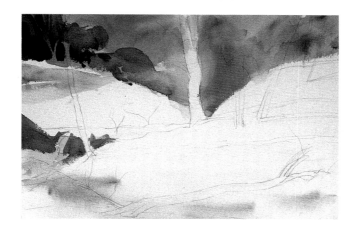

*Step 3: Wet the fore-
ground with clear water,
and wash on shadows.
Here, Wisnowski uses
cobalt blue and burnt
sienna for the snow area.*

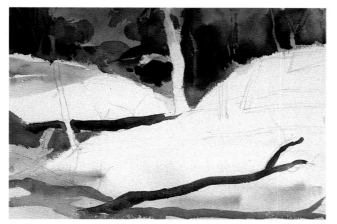

*Step 4: Once the S pattern
is established (here, with
logs and middle-ground
shadows) add background
dimension. Wisnowski
enhances detail with
negative shapes of trees.*

Whether you are a one-day artist, a traveling artist, or a studio painter with dreams of being on the move, you must consider more than values, patterns, and shadows to paint successfully. Wisnowski teaches his students the eight classical elements of design—which he also interprets in much of his work.

"SIZE"

"SHAPE"

"ANIMATION"

"SPIRIT"

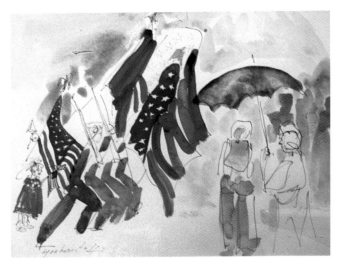

Memorial Day Parade,
Rockport
Lynn Leon Loscutoff
An impressionistic stroke
captures movement and
mood quickly.

When painting a crowd, capturing the action is essential. So is getting your artwork (and yourself) out in one piece. You have to find a space to paint where you can see the action, but where you are not in danger of being trampled. I began this particular painting trip with a passing Memorial Day parade. After watching and painting from the car, I hopped out to get a closer look. I stuck a shoulder strap to my water-color block and grabbed a plastic container to tote water and brushes. In addition to the ability to be spontaneous and jump into the middle of things (armed with paint and paper), the trick to truly making crowd scenes come alive

on paper is capturing a 1-2-3 storytelling depiction of a scene. Artist Franklin McMahon is a good at both.

In 1950, McMahon abandoned his studio for the road. He now specializes in recording major events as they happen; finding the story behind the picture by being there.

Capturing Details

Camera equipment can be essential: Painting quickly invariably means leaving out some details. The moment you start painting, a Polaroid shot can capture the day, the light and shadow, and the local action: stick the photo immediately into your sketchbook. Though cumbersome, a video camera will record yet another dimension of your surroundings—and you can make notes on the audio portion of the film. Back in the studio, sights and sounds on the videotape create the mood of being there again.

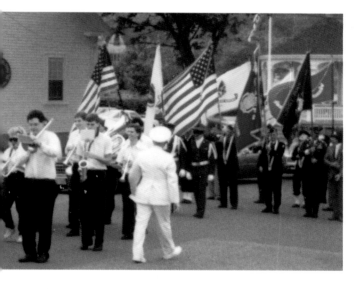

A photograph of the parade for later reference.

Painting Scenes of Action

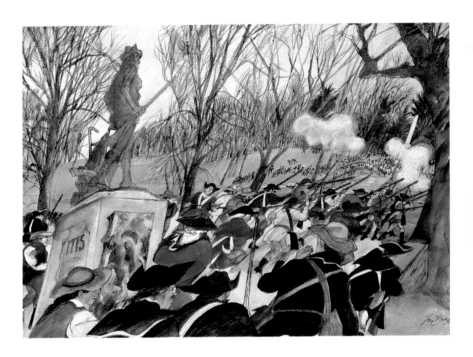

The underlying drawing is an integral part of McMahon's paintings.

Although he draws and paints in the middle of crowds, Franklin McMahon works on a large surface; most often sheets of 22" × 30" (56 cm × 76 cm) 140 lb. Arches cold press paper.

An unusual combination of artist and reporter, McMahon has painted pictures of the opening ceremonies of the Vatican II Council in Rome, covered the establishment of the European Common Market, made paintings of more than 30 presidential candidates, and chronicled

the presidency of John F. Kennedy. Because of his versatility and ability to work quickly on site, McMahon is much in demand—whether for *Sports Illustrated* magazine, or for this assignment painting the reenactment of an American Revolutionary War battle for *Yankee* magazine.

If you are serious about capturing the excitement of a crowd, battle, or parade, McMahon advises walking the site a day early. That will give you time to plan your position and choose a spot—or spots—from which to watch and work. Prepare all of your materials in advance as well. McMahon bundles several sheets of watercolor paper together with protective outer layers of Kraft paper, and includes a piece of heavy cardboard to use as a drawing board. In a sheath in his pocket, he carries a supply of sharpened Berol Veriblack 315, Ebony Design, and 2B General Charcoal drawing pencils.

The artist tries to go to the site the day before an event; to get his bearings and to pick a good spot to protect himself from onlookers and, sometimes, from the action.

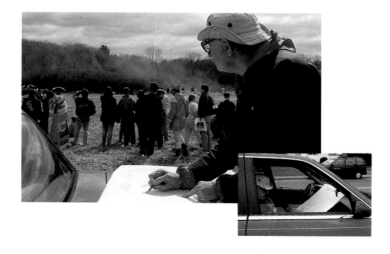

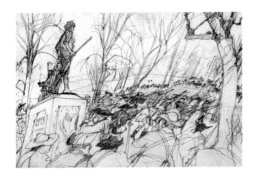

For this project, McMahon followed "British Redcoat" soldiers, sketching them as they marched over a bridge to skirmish with the approaching "Minuteman" soldiers. After a quick volley of shots, the Redcoats retreated.

McMahon started the drawing of the battle with Daniel Chester French's Minuteman sculpture. However, he was not allowed to stay in that position during the battle, so he withdrew to the press area and finished sketching the soldiers from a new vantage point.

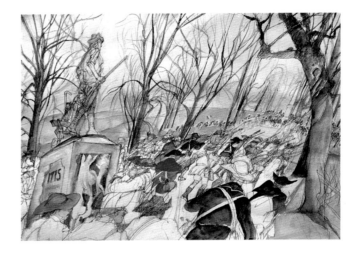

He established the Redcoat soldiers on the other side of the river, against the green of the landscape, then added tinges of orange and yellow to suggest the early morning hour.

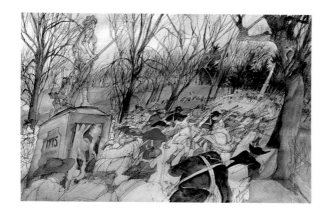

McMahon wanted to include the arched bridge in his drawing, so he began to feel his way through the maze of lines making up the Minutemen soldiers.

The shapes of the Minutemen and the long muskets are singled out of the interlacing pencil lines.

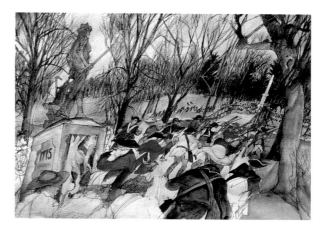

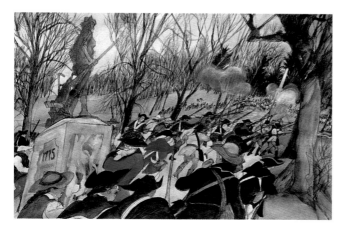

The finished painting, one in a series created for Yankee magazine to depict the reenactment of the Battle at Old North Bridge.

BY TRAIN

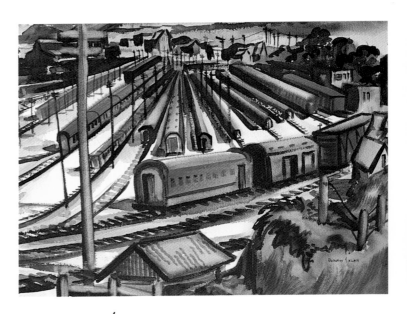

Train Yard, *Dorothy Sklar*

*T*rain rides are especially wonderful for traveler-artists. The roomy seats, large windows and calm rhythm of a train make an ideal environment for watching the passing landscape and capturing it on paper. The hardest part is composing the picture: On foot, you can place yourself where a composition is ready made. When in motion, you put the puzzle together as you go. If you do decide to paint during a train ride, pay attention to shapes and to establishing planes. These elements of painting are just as important when the paper is on your lap as they are when it is on an easel; if done poorly, they will stand out no less because a painting is small.

My approach is to make a rough composite of the landscape first, drawing on the scenery as you move past.

Concentration is especially important at this stage, since you must compose as ideas of the passing images present themselves.

One of my friends, Russian-born artist Serge Hollerbach, takes special delight in painting on the train. He is fond of sneaking watercolor sketches of fellow passengers in his small sketchbook. Sometimes he paints on postcard stock—then mails the finished card to a friend. I recently received such a postcard from him:

Dear Fellow Globetrotters:

I write this to you as I travel from Moscow to Leningrad (St. Petersburg) on the overnight train. Normally I would be sketching all of the passengers and the passing scenes. On this overnight express, I am too excited about the prospect of having been invited back to my native land as a returning Russian immigrant, to exhibit and be honored for my art accomplishments. My work will now be included in the permanent collection of the Trejakow museum. I have traveled and painted for more than 40 years. I hope that your journey will lead you to the adventures I have experienced.

Sincerely,
Serge

Serge Hollerbach uses many of his little watercolor paintings to compose large acrylic paintings back in his New York studio.

Sneaky Sketches

A small sketchbook helps capture images of the Russian travelers who wait on the platform.

Workers mingling on the train platform after a hard day at work.

For Serge Hollerbach, the human figure is by far the most fascinating subject for art. He sketches and paints figures everywhere he goes, and admits to being a sneaky sketcher. He carries a version of bag #1 with him at all times. In it, his tiny Winsor & Newton traveling paint kit is almost worn out. Most of all, he loves painting people doing things and going places—waiting at the train station or riding on the train or the subway. Where are they going? What is happening in their lives?

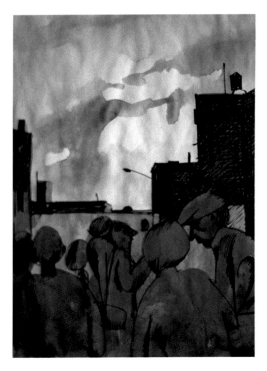

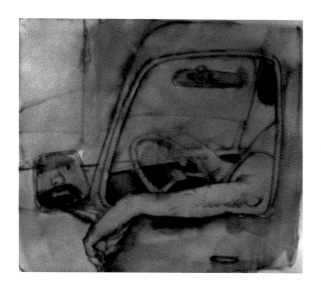

As a rule, Hollerbach feels that it is important to paint a place before you leave it, or soon thereafter, to ensure that you have a satisfying composition. But even more important, he says, is that you approach painting with a joyful attitude.

Before you begin to draw a figure, Hollerbach advises placing three pencil marks on the paper—one each for the head, the waist and the feet. Then load a brush with a medium-value color and start painting a little above the mark for the torso. Add the head and feet later, once the paint on the torso is dry. Following this technique will help you paint figures in proportion, and will keep you from making your figures' heads too large.

Hollerbach captured this fleeting view—reflected in a rearview mirror—of a man resting his arm out of the window.

Hollerbach has a sentimental companion in his bag #2—an old metal paint box that holds a watercolor block. He carries it when he rides the train—whether in Moscow or New York— and sketches the passersby he sees from his window.

The artist paints human shapes that he finds interesting and compelling.

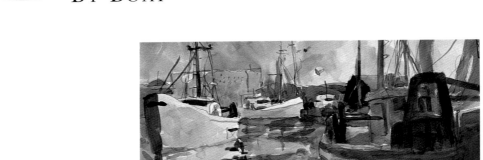

Jankowski often reverses his colors, using the complement for the actual color. If something is blue, he might paint it in orange, much like the Fauves—who painted yellow and purple faces that seem right because their color values are correct.

Being on a boat, even a rowboat, stimulates the desire to master the motion. What are the masts doing? What are the sails doing? Patterns, both abstract and real, are all around; boat rigging-lines going in all directions supply real and implied lines for composition. Interested in atmosphere? Try fog, crashing surf, tide pools, storms, or ship wrecks, just for starters.

Boats and harbors are fascinating all over the world. Harbors suggest commerce, discovery, cruising, and fishing. Like many traveler-artists, I have never seen a harbor I didn't want to paint. Grab your tried and true art bag and set sail.

I anchor myself when painting on a boat. The wind and surf can sail away a painting, or spray a fine mist on a water color: but, it feels so good.

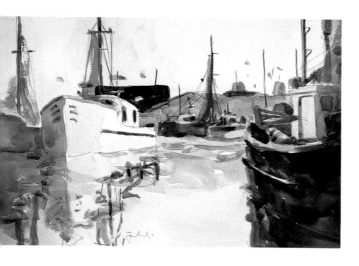

A painter who makes harbors vibrate is Zygmund Jankowski. Watching him work at Gloucester Harbor in Massachusetts is a joy. He moves quickly, wiping his brush on his trousers. Often, he paints with Oriental brushes—moving and bobbing to some imagined rhythm. He holds you with his moving color as well as his moving brush.

He works from nature, but makes it his interpretation. His paintings do not necessarily have a center of interest, he works from top to bottom, side to side. Jankowski stresses the importance of painting every day; he makes several paintings each day at home or while traveling.

He is captivated by the Gloucester fishermen and their lives. "It makes you want to take that life," he says, "taste it, devour it, spit it out and try to paint it."

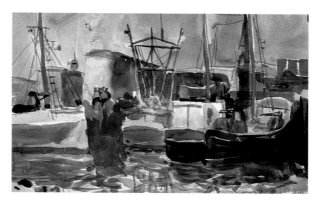

Water/Colors

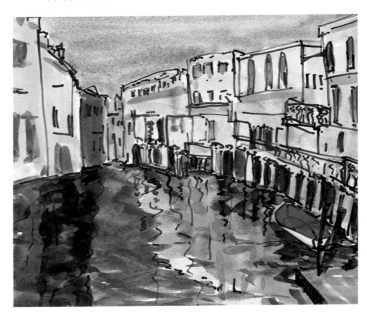

The sky is always lighter than the water. Cerulean blue can do a lot in a sky. I used complements to dull some of the reflections, and I deepened shadows in doorways and under pilings.

As an artist, you always need to be prepared for surprises. For instance, on a recent trip to Venice, before we had unpacked, a fellow traveling artist surprised our group with a waiting gondola ride. Did I waste it? No, art à la carte (bag #2) and I climbed aboard. First, I took a photograph of the beautiful buildings reflected in the canal. The red boat added just the right contrast. Next, I did a quick sketch using one of my favorite traveling techniques—a permanent ink drawing with a brown Staedtler Lumicolor pen. I checked the color reflections, "mirror images," and sketched the ripples of movement. Then I painted with a palette drawn from the colors of the buildings, but darker and deeper.

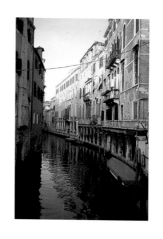

A photograph looking down a Venice canal.

When you paint by boat, remember that reflections of light-colored objects appear darker in the water, whereas reflections of darker objects appear slightly lighter. Remember, too, that boats can pitch; I balanced my watercolor block carefully on my lap so that I did not appear wetter and cooler.

In watercolor, one usually works from light to dark. "Punching in" darks makes light colors appear even lighter. But even in the darkest areas, like the shadows under the buildings in this painting, a little dab of warmth should be added for reflected light. This is what I call an energy painting—just quick, fun, and capturing a moment in time.

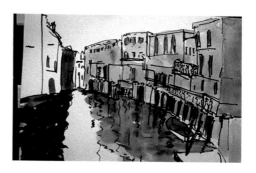

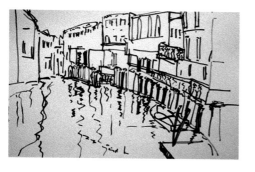

With myself and my paper carefully balanced in the narrow gondola, I made this quick sketch on 10" × 14" (25 cm × 36 cm) Arches hot press paper.

I used Naples yellow, yellow ocher, lemon yellow and alizarin crimson to vary tones on the buildings. A mixture of cobalt blue and thalo green dulls some spots, while French ultramarine, cobalt blue, thalo green and alizarin crimson create dark areas, doorways, and shadows under the buildings.

BY PLANE

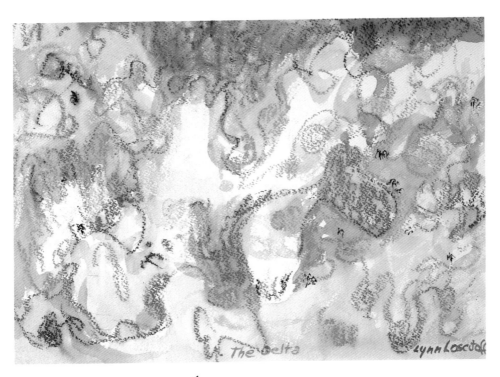

The Delta *Lynn Loscutoff*

The Okavango Delta in Botswana, painted from a small plane. Traveling by Land Rover, bus, and small plane through Zimbabwe and Botswana, I had to be resourceful, inventive, unobtrusive, and fast.

Basically, there are three approaches you can take to painting by plane: you can finish paintings begun in wild locales (like the scene you never finished because the elephant started to charge), a good approach for long plane rides home; you can take a commercial flight and try to capture the landscape quickly, through the tiny window, before it is obscured by clouds; or you can do what I did and fly over land in a small plane.

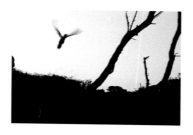

With my photographer's vest stuffed full of film, cameras, and sketching material, I

packed bags #1 and #2 and decided to also bring a video camera and other photographic equipment. Painting is my love, but when I want to record a bird in flight in the twilight of an African day, my camera becomes a close friend.

Flying over the Okavango Delta in Botswana, Africa, I watched the winding patterns of the chartreuse delta waters traveling snakelike through the golden grasses. I used a medium size, cold press watercolor block (10" × 14"/25 cm × 36 cm) and another traveler's boon—water-soluble crayons (I prefer Caran d'Ache Neocolor II. They also make a good water-soluble pencil.) The crayons can be used for highlighting or for drawing, and can be blended with water or used alone. I sometimes keep a small set in bag #2, and I put them to good use on this beautiful African morning.

A bird flies overhead at dusk. Traveling through Africa's free-roaming wildlife is an image maker's dream.

I took photographs from the window of the "Flight of the Angels" over Victoria Falls in Zimbabwe. I was too captivated to try to juggle a camera and paint in the rolling plane, so I drew the picture (with Caran d'Ache watercolor crayons) once I was safely back on the ground.

BACK HOME

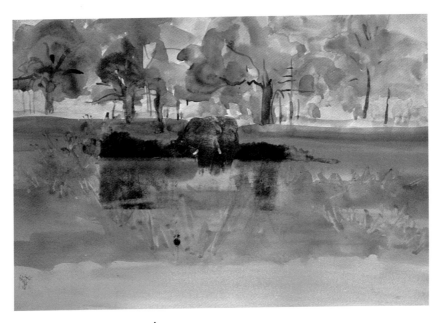

The color photocopy image of the elephant was transferred to hot press paper prepared with lacquer thinner. If you don't have a lithograph press, rubbing the back of the photo copy (while it is face down) with a pencil, spoon, or any other round tool will also work.

Traveling by plane, bus, train and car can exhaust even the most seasoned traveler-artist. Returning home after an invigorating trip of painting and traveling has many rewards. You can set down your backpack and art-supply bags and stretch. You can unpack your work and review your accomplishments. You can take your art work one step further, experimenting with processes that are done best in the studio.

Throughout my trip to Africa, I painted. From small airplanes, from Land Rovers, on walks with guides, on quiet afternoons around the camps, I painted. I painted hippos bathing in the delta, African daisies and waterlilies, and the winding paths of the Okavango River. I photographed lions, zebras, impalas, giraffes, hyenas, hippos, and crocodiles. And I photographed a wondrous African elephant.

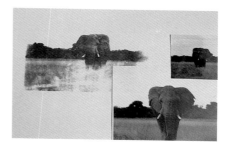

At home in the studio, I decided to combine photographs and watercolors using a sequence of photos I had taken of the elephant. You can create a kind of ghost image by copying a photo with a color photocopy machine. In this instance, I enlarged the image and made several different sizes of the copy.

I did not crop the photo of the elephant before copying it.

Next, I transferred the photocopies to watercolor paper. A lithograph press is ideal for applying enough pressure to make the transfer, but a rolling pin and a brayer work fine, too. To make the transfer, sponge some lacquer thinner* onto a sheet of smooth or hot press watercolor paper. Place the copy face down on the prepared sheet and press. Transfers can be made to already painted paper, but in this example I painted after the transfer was made.

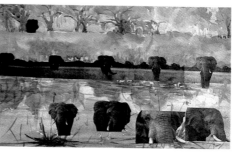

Another example of a painting combining photocopies and photographs.

I combined some real photographs with the photocopies, then added a painted African landscape. Seal the entire surface of the painting when you finish. There is really no "wrong" way to do this process—experiment and have fun mixing different images.

The memories and images captured in the paintings and photographs of my trips are my treasures. Traveling and painting is an adventure. I hope that I have helped to prepare and inspire you, whether you venture out on a bus, a plane, a train, a boat, or on foot, to experience the world through painting.

**Use lacquer thinner in a well-ventilated space, and carefully read all label instructions.*

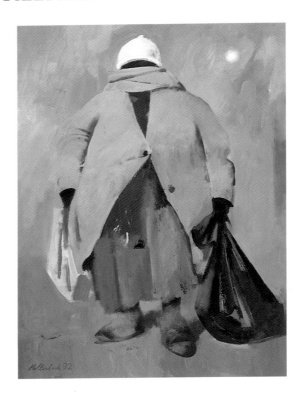

Homeless Woman
Serge Hollerbach

Who said an artist could be a free spirit and float like the wind? As always, organization keeps us sane and able to retrieve information. Your sketchbook should contain information such as dates, locations, local color, paintings of entire scenes, sketches, and paintings of isolated objects to be combined with other objects.

Label your Polaroid photographs with the time of day and the subject. Later, you can add other photographs and memorabilia. Label the cover of the sketchbook with the trip and the date. You will be surprised at how soon you have a sketchbook library.

If you take photos instead of slides, you can lay them on the pages and make the most wonderful book of your own with a laser copier. A friend did this with her photos, typed up her notes, and presented her traveling companions with a booklet of their trip.

Archival slide pages, both vertical and horizontal, can be hung on hanger bars or put in binders. A photo archival system holds negatives in sleeves and cross-references them with photographs.

Keep file folders with your photos, newspaper and magazine clippings, and travel brochures. When you are looking for finishing touches or a remembered impression, it helps to have a detailed record. Also, if you go out painting and there is not a cloud in the sky, how handy to have a cloud formation or sunset file. Index files according to subject: legs, feet, hands, etc. Store photos, negatives, slides, and other archival material in acid-free storage file systems.

Later, when you are busy selling your art work all over the world, you will have a record of where it began.

Sketch Library Story

I recently traveled to the primeval oasis of the Okavango Delta, a part of southern Africa that supports an unparalleled diversity of wildlife. The continent's largest population of unharnessed elephants find refuge in this breathtaking region. Riding crazily in a land rover, I spotted elephants romping with their families. A kindred feeling developed within me as I became more aware of the family interaction of the elephants swimming, bathing, playing, and caring for the smallest young by corralling them in the center for protection. A videotape of 75 elephants bathing is part of my sketch library.

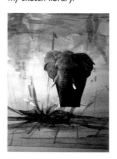

The companies listed are good sources for many of the art supplies mentioned in this book. Items in italics are products recommended for traveling painters by Lynn Loscutoff. No responsibility is assumed for companies who have changed their addresses or phone numbers, changed their names, changed the names of their prod-ucts, or neglected to phone their mothers on Mothers' Day.

American Artist Magazine
P.O. Box 2012
Lakewood, NJ 08701
The Georgian Watercolor Box (with tubes, fits in pocket)

Aquarelle
P.O. Box 3676
Baton Rouge, LA
70821-3676
504-926-4220
Easy Easel, Shapemaker double-ended paint brushes

Artist Connection
600 US Highway 1 So.
Iselin, NY 08830-2635
800-851-9333
FAX 800-852-9333
Brushes, folding brushes

Art Pac
3483 Edison Way
Menlo Park, CA
94025-1813
800-348-2338
Art Pack artist's back-pack

All Seasons Products
37 Passaic Street
Garfield, NJ 07026-3134
201-591-0888
Artist's Seat Bag

ARTSMART
84 Langsford Steet
Gloucester, MA 01930
508-283-0782
Artist's travel resources, supplies, studio exchanges, painting trip directory for traveling artists

L.L. Bean
Freeport, ME 04033
800-221-4221
Creative Traveler's Versalite (flashlight)

Dick Blick
P.O. Box 1267
Galesburg, IL 61402
800-447-8192
Artist Pack Stool, art supplies

Cheap Joe's Art Stuff
374 Industrial Park
Boone, NC 28607
800-227-2788
Adjustable height chair with back

The Civilized Traveler
54 West 21st Street
Suite 505
NY, NY 10010
212-758-8305
Folding umbrella with clip (to attach to a chair), Double Header flash-light, Chase Away bug repellent

Robert Doak Associates
Dept. AA
89 Bridge Street
Brooklyn, NY 11201
718-237-1210
Disposable plastic palettes, art supplies

Exposure
1 Memory Lane
P.O. Box 3615
Oskas, Wisconsin
54903-3615
800-222-4947
Archival boxes for storing negatives, photos, slides

Hewitt Painting Workshops
P.O. Box 6980
San Diego, CA
92166-0980
619-222-4405
Painting and traveling workshops

Light Impressions
280 Commerce Drive
Rochester, NY 14623
716-271-8960
FAX 800-828-5539
Saf-T Stor-Pages, Photo Archives

New York Central Art Supply
62 Third Ave.
NY, NY 10003
800-950-6111
FAX 212-475-2513
Fine art paper

Pearl Art Supplies
308 Canal Street
NY, NY 10013
212-431-7932
FAX 212-431-6798
Folding brushes

Rock Hill Associates
Neil and Susanne Rappaport
RD 1 Box 1255
West Pawlet, VT 05775
802-645-0821
Personalized software for keeping trip records

Silsby Technologies
P. O. Box 267
Amherst, NH 03031
603-672-4570
Field Artist Portable Studio (includes tripod, tray, board, canvas bag)

Dr.'s Foster & Smith, Inc.
2253 Air Park Road
P.O. Box 100
Rhinelander, WI 54501
800-826-7206
Aluminum cage or crate dish (dog's water dish)

Daniel Smith
4150 First Avenue South
P.O. Box 84268
Seattle, WA
98124-5568
800-426-7923 U.S.A.
800-426-6740 Canada
Blocks of Daniel Smith Indian Village Postcards watercolor paper, folding brushes

Tubes in Time
P.O. Box 369
New Oxford, PA. 17350
800-242-5216
Mailing tubes

Utrecht
333 Mass Avneue
Boston, MA 02115
tel - 617-262-4948/
800-257-1108
Paints, brushes

Yarka Fostport, Inc.
65 Eastern Avenue
Essex, MA 01929
800-582-ARTS
24-color Traveling Paint Kit, Paints, Kolinsky Sable and Siberian Squirrel hair Brushes, folding brushes, easels

DONG KINGMAN, of Oakland, California, is a master watercolorist, author, instructor, recipient of the Guggenheim Fellowship, WPA artist, member of the Famous Artists School of Connecticut, leader of painting workshops for the past 40 years, and a renowned, internationally collected painter. A film is currently being completed of his life and work. Kingman's works are in nearly every major art museum in America. He has been the honored artist of more than 53 awards, and has traveled and painted in every major city in the world. He currently resides in New York City, New York.

SERGE HOLLERBACH, A.W.S. Author and instructor Serge Hollerbach was born in Russia, and educated in Munich, Germany and in New York City (where he now makes his home). His works are in the collections of the Yale University Art Gallery, the Butler Institute of American Art, the National Academy of Design, where he is also an instructor, and many other prestigious museums and galleries. Widely honored for his contribution to American Art, his work is also displayed in the permanent collection of the Trejakow Museum in Leningrad, Russia.

NANCY SARGENT HOWELL lives in Dedham, Massachusetts. She attended Skidmore College, where she assisted in teaching drawing. Past President of the New England Watercolor Society, she is currently a member of the Copley Society and the New Hampshire Art Association. She is represented by the Market Barn Gallery in Falmouth, Massachusetts; and up and down the East Coast, from New England to Gallery One in Sarasota, Florida.

JAMES WISNOWSKI is a native of Chicago and a graduate of the American Academy of Art. He has been a member of the staff of Ray College of Design in Chicago, the Chicago Museum of Natural History, the Old Town Art Center, and the Discovery Center of Chicago. For 14 years, he has

conducted watercolor classes and workshops throughout the United States and Europe. His paintings are found in many U.S. corporations and in various private collections, and have been displayed in a number of national exhibitions. Wisnowski is the recipient of numerous national awards.

ROBERT A. WADE, known as the Australian Ambassador of Watercolor, is a member of A.W.I., Knickerbocker Artists of New York, a Fellow of the Royal Academy Society of Arts, London, International Society of Marine Painters, USA and is an Honorary Member of the Mexican Watercolor Society. Among his one hundred major awards, seven are from the Salmagundi Club of New York; he has also received the Cornellisen Award of the Royal Institute of Painters, London, and three Gold medals from the Camberwell Rotary Club. Wade has traveled and painted for the past 50 years; between trips, his home base is Mt. Waverly, Victoria, Australia.

FRANKLIN MCMAHON is an artist, author, and film maker. He has received the Art Institute of Chicago's Renaissance Prize, and his work is displayed in museums throughout Europe and the USA, including the National Air and Space Museum in Washington, D.C. He was a member of the Famous Artists School of Connecticut, and is the producer-director of a television documentary series on art for PBS and CBS. McMahon holds two honorary degrees; has been named Artist of the Year by the Artists Guild of New York; and has exhibited work in one-man shows in countless museums and galleries. He resides in Lake Forest, Illinois.

ZYGMOND JANKOWSKI, CM, born in South Bend, Indiana, and now residing in Gloucester, Massachusetts, has taught painting from coast to coast, and paints and travels widely. When asked for his biography, Jankowski replied, "I am a painter."

NOTES

NOTES

NOTES